CROSS PURPOSES
AN INTRODUCTION TO MEDIAEVAL MANX CROSSES

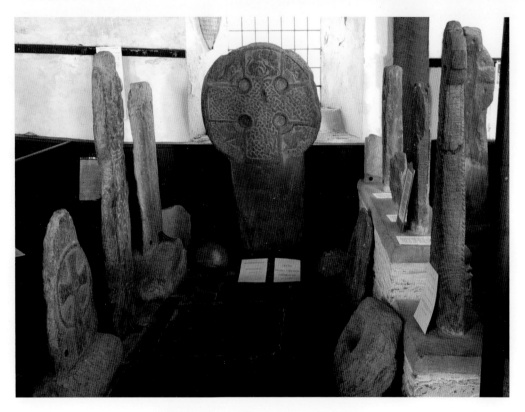

SARA GOODWINS

HOOFPRINT SERIES 7

Loaghtan Books
Caardee
Dreemskerry Hill
Maughold
Isle of Man
IM7 1BE

Published by Loaghtan Books

First published: April 2020

Typesetting and origination by:
Loaghtan Books

Printed and bound by:
Page Bros Print

Website: www.loaghtanbooks.com

ISBN: 978 1 908060 30 3

For
Catherine Milsom;
this book seems appropriate.

Front cover: Olaf Liotulfson's cross in Ballaugh old church

Rear cover: Gautr's cross in Kirk Michael church

Title page: Cross collection in Braddan old church

CONTENTS

The human element 4

Chronology 13

Fantastic beasts
 and where to find them... 19

Mann is not alone 26

ACKNOWLEDGEMENTS

The author is indebted to several organisations and individuals who gave up their time to provide help, information and/or photographic material. They include, individuals: Katie Byrne, Angela Lake, Barney McLaughlin, Laura Shanahan, Sharon Sutton, Jo Woolf; and organisations: The Board of Trinity College Dublin, the Victoria & Albert Museum London.

Always of course I am grateful for the support and photographic expertise of my husband, George Hobbs.

Thank you all for your help and assistance; any mistakes are entirely mine.

Hoofprint series
A De-tailed Account of Manx Cats
Things to do with Vikings
Three Legs Good; the story of the Manx triskelion
Mann with Altitude
Two Fish for the Summit; life and work on the Manx mountain
A Manx A-B-C-Dery; an Alphabetical Tour of the Isle of Man
Cross Purposes; an introduction to mediaeval Manx crosses

People have always wanted to make their memories permanent – just visit Douglas Head and count the number of memorials commemorating different people and events, or think of the number of selfies taken. Those who erected the Manx crosses were no different. The cross stones provide us with a direct connection to named individuals who lived on the island a thousand years ago. The crosses also provide tantalising glimpses of the way of life and beliefs of the people who made them.

Gautr's cross, Kirk Michael; the runes are highlighted where he signed it

Who erected the crosses and why?

We're used to a prospect which has been moulded by people. Even the wilder uplands have been shaped by people grazing animals, cutting peat and silage, and harvesting trees for firewood. The landscape seen by those who carved the old Manx crosses would have been much wilder. The island had a largely absentee ruler, at first Irish and then Norse, and there was a lot of land which was unclaimed even for rough grazing. Settlements of any size were almost non existent and people lived in scattered farmsteads based around the family unit. Small chapels or keeills served every four farms, with the priest living next to his church; he probably ran a smallholding with a few animals as well as performing his spiritual duties. The society was rural, hard working and had little leisure time. Consequently, erecting a stone cross would have been a large and expensive undertaking; it wasn't done lightly. Each cross and the person or event it commemorated would have been very important to whoever commissioned it, just as modern headstones are important to those remembering loved ones today.

As not everyone could afford one, the crosses provide glimpses of what might be called the middle class of the time. Some individuals are even named. Gautr's cross in Kirk Michael, for example, (see left) says, in runes: 'Malbrigþi son of Aedhacan the smith raised this cross for his soul'. As a smith, Aedhacan was a highly important and respected member of his community, and therefore a man of means; his family would have been comparatively well off. Another cross, says in Ogham (see page 14 for more about Ogham) that it is the stone of 'Dovaidu, son of Droata', or possibly

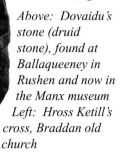

Above: Dovaidu's stone (druid stone), found at Ballaqueeney in Rushen and now in the Manx museum
Left: Hross Ketill's cross, Braddan old church

'Dovaidu, son of the druid', which might indicate that druids were present on Mann at the time. Of Hross Ketill's cross there is only a fragment left, but its runes say, tantalisingly: 'But Hross Ketill betrayed in a truce his own oath-fellow.'

Three or possibly four of the Manx crosses have Latin inscriptions. One, known as Maughold 169, of which only a fragment remains, says in Latin '[in the name of] Jesus Christ, Branhui brought water to this place.' Branhui seems to have

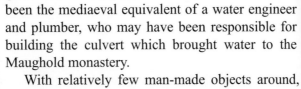

Mal Lumkin cross,
Kirk Michael

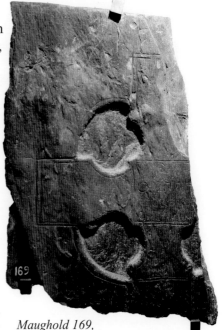

Maughold 169,
Maughold cross house. The
Latin inscription is in the square in
the centre of the cross arms

been the mediaeval equivalent of a water engineer and plumber, who may have been responsible for building the culvert which brought water to the Maughold monastery.

With relatively few man-made objects around, and where even dwelling places were more likely to be made of wood, wattle and daub (mud-covered wooden framework) than stone, the stone crosses would have been a particularly noticeable and impressive landmark. Just like man-made objects today, the inscriptions indicate that there were all sorts of reasons why the crosses were erected. Many are memorials, some are markers either of graves or the boundaries of ecclesiastical settlements, some were possibly meeting places for prayers, rites or ceremonies. A few might even have been erected for self aggrandizement, to demonstrate wealth, proclaim piety, or express sentiments about a relative, friend or chief. They were not necessarily all erected for religious purposes – although many were – and were by no means always intended as burial markers.

Who carved them?

The Manx crosses might be called crosses, but they're not all cross shaped. Most are made of slate, which is plentiful on the Isle of Man. Slate is relatively easy to split into slabs, and has useful flat surfaces which can be incised with designs or inscriptions, but is difficult to cut into shapes without the risk of it splitting. Consequently the crosses are often, although not always, carved into a flat surface.

The crosses, particularly the later ones, would almost certainly have been carved by someone whose job was stone carving, i.e. a professional and not an amateur. Craftsmen working in the same trade tended to live in the same area, co-operated to share materials, and possibly helped each other fetch those materials, particularly if they consisted of large and heavy blocks of slate. In addition, such specialist craftsmen might have learned from each other, possibly shared the training of apprentices, and worked together to protect their trade secrets. The arrangement would have been the precursor to the later

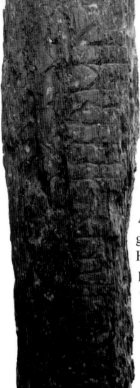

guilds. There would have been rivalry, of course, but the benefits of co-operation probably outweighed any jockeying for position. The Celtic custom of fostering, where young children were placed in a foster household to learn expertise their parents didn't have, would have helped pass on cross-making skills. The runes on the Mal Lumkin cross (see page 5) actually mentions fostering: 'Mal Lumkin raised this cross in memory of Malmury, his foster mother, Dufgal's daughter, the wife whom Aþisl owned. Better to leave a good foster son than a bad son.'

The Isle of Man may not have had enough work to support a community of cross carvers, so may have had only had one carver at a time, who took an apprentice as necessary. This seems to be partly confirmed by one of the crosses itself. The cross erected by Malbrigþi, now in Kirk Michael (see page 4) is called Gautr's cross rather than Malbrigþi's, because the inscription goes on to say: 'Gautr made me and all in Mann'. Early advertising! However, as the crosses were carved and erected over a six-hundred year period, Gautr couldn't have made *all* of them! He probably did however carve all the crosses on Mann during his working life.

Just as monumental masons today occasionally add their name to the back of a headstone, Gautr signed one other Manx cross, now in Andreas church. It provides a little more information about him. The runic inscription on the Gautr cross in Andreas (see left) is now incomplete but what is left says: 'this to the memory of Ófeigr his father, but Gautr made it, the son of Björn of Kollr.' Experts disagree as to where Kollr

Hedin's cross, Maughold cross house; the outline of the Viking ship is highlighted

is, some thinking it's the Hebridean island of Coll, others that it's the name of a local Manx farm. *Cooill*, which could be argued as being similar to kollr, means corner or nook in Manx.

A few other crosses on the island are also signed; Osruth's cross pictured in St John's church (see right) but at the time of writing awaiting conservation in the Manx museum, proclaims on its left edge 'Osruth carved these runes', while Thurith's Cross in St Peter's Church, Onchan – unusually the runic inscription is a very late one – explains that '…son erected this cross to the memory of his wife Murkialu.' The more interesting runes are on the back, where the inscription states that 'Thurith wrote these runes'. Thurith (*Þúríþ*) is a woman's name. Female literacy was not uncommon, but there is no other known example from this era of a woman carving an inscription on stone. It is however possible that the lady commissioned the work, rather than actually carving the runes herself. Unfortunately, as the cross is displayed attached to the church wall, the 'signature' runes can't now be seen.

Hedin's cross (see opposite page), now at Maughold, has two sets of runes. One explains: 'Hedin set this cross to the memory of his daughter Hlif', the other 'Arni carves these runes'. This cross is also notable for being the only one on the island which carries a carving of what appears to be a Viking ship. Experts claim that the design is a graffito and added later, but such relatively detailed carving would have taken time and, if the carver were unwelcome or unofficial, they would surely have been stopped. Hedin's cross is a late one, dating from the eleventh century, but could Hedin or Arni be claiming a link with the Norsemen?

What tools did they use?

The hand tools used by masons have not really changed at all in thousands of years, and the basic shape of a modern chisel is almost identical to ones used to build the pyramids of Egypt. The Manx crosses would therefore have been carved by someone using a metal chisel and a wooden mallet or maul recognisably similar to those used today. The stonecarver would probably first have roughed out his design using chalk, or, if none were available – chalk does not occur naturally on the Isle of Man – used a mud paste to outline the design. The time needed for the actual work of carving varied, of course, according to the size of the cross, the hardness of the stone, the skill of the carver and the complexity of the design, but an approximate rule of thumb would be about three hours for every square foot.

Crosses would always have been carved before being placed in position, although whether in some sort of workshop or on site cannot now be known, and might anyway have varied. From research done on Irish high crosses (see page 26), it seems likely that almost the whole design would have been carved before the cross was erected, but that each may have been 'touched up', or the fine points of the carving completed once in position.

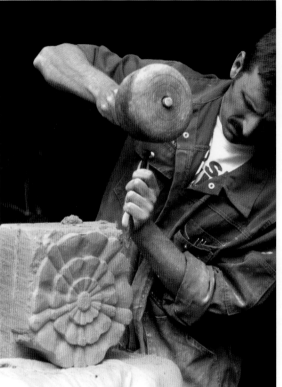

Stone carver, using maul and chisel, Painswick Rococo Garden, Gloucestershire

Where did the stone come from?

No-one would choose to carry something large, heavy and unwieldy any distance without good reason so the Manx crosses are mostly made from local stone. Yet there is a trade off; do you quarry a slab in your own backyard, or do you transport a ready-made slab from a little distance? Several cross fragments are certainly not of local stone, including one displayed at Braddan old church. Carved from sandstone, it has been suggested that the cross was made out of sandstone left over from that brought to the site when the old church was first built.

As has been said, however, most Manx crosses are slate. Slate is a stone which cracks easily, if sometimes unpredictably; a property which miners use to separate chunks of rock. Wedges are hammered into small cracks to widen them and eventually the rocks split along the opening to detach beds of slate. The same effect can be produced by water as it settles into cracks in the rock and then freezes, forcing the cracks wider. The cycle repeats until the rock eventually detaches from the hillside, forming scree. The top of North Barrule, the Isle of Man's second highest peak, is made up of rock

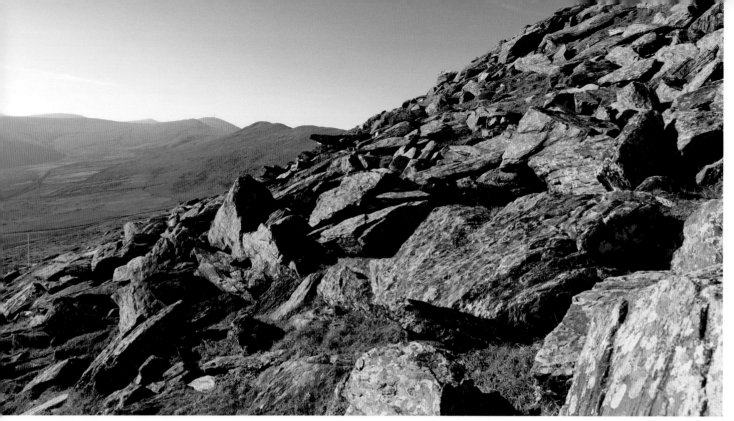

of the Manx Slate series, which was formed during the Cambrian age (541-485 million years ago). Much of the slate in Wales was formed at the same time. High on the shoulder of the south side of North Barrule, thousands of pieces of slate litter the ground (see above). The rock is the same type as that used for the stone crosses, and the larger pieces are also very much the same size as the largest of the crosses. It is also a fact that the north of the island has a larger collection of crosses than the south. Perhaps the abundant selection of raw materials had something to do with it?

How was the stone moved?

Very few of the Manx crosses still stand where they were first erected, but some have been found in places such as Andreas, Bride and Jurby, all of which are relatively low-lying areas, often boggy, and without a great selection of natural slate. Stone for the crosses, or the crosses themselves, must therefore have been brought there.

Transporting the large slabs was probably done by tying them to a rudimentary wooden sledge which slid relatively easily over the grass on the hills, and, on the flat, could be pulled over logs laid at right angles to the sledge which would act as rollers. Slabs could also have been floated on rafts down waterways. Cleopatra's needle, the obelisk made in 1450 BC and which now graces the Victoria Embankment on the Thames in London, was brought from Egypt tied to a makeshift raft, and experts think that the bluestones of Stonehenge were transported 140 miles from the Preseli Mountains in Wales in a similar fashion.

The Manx crosses are much smaller than either Cleopatra's needle or the Stonehenge blocks, and it is possible that six or eight people could have carried even the largest ones, either on their shoulders on poles, coffin-like, or in rope

hammocks slung between them. A cross slab approximately six feet tall by two feet wide by four inches deep would weigh about a third of a ton.

Not all the material for the Manx crosses would have come from North Barrule of course. Some would almost certainly have been made of local stone, depending on the carver's – and the client's – preferences, and the suitability of the stone itself. The Maughold wheel cross (see page 31), for example, was found in the churchyard and a local mason identified the stone as from Pooilvaaish, near Castletown.

How erected?

So, if the crosses were fabricated off site and transported to where they were to be displayed, how were they erected once they got there? There seem to have been two methods used. The most obvious was to set them into the ground by digging a deep hole, sliding the base of the stone into it, raising the stone vertically with ropes, and then backfilling the hole. Thorlief's cross at Braddan old church (see below), and Osruth's cross (see page 6), for example, seem to have been originally raised using this method.

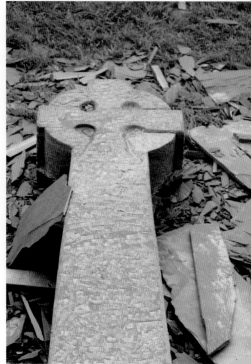

Replica cross being carved in the grounds of the Cathedral Church of St German, Peel

The second method of raising the crosses was by leaving a tine of slate protruding from the base of the cross, and inserting the tine into a slot cut into a slab of stone laid flat on the ground (see picture overleaf). The cross in the churchyard at Lonan old church was erected using this method and other crosses, no longer in their original location, show the characteristic tine at the base.

There doesn't seem to be a reason – or not one that we can work out with any certainty at this remove of time – why one method was favoured over another. It could be that building techniques changed over the centuries, or that those erecting the cross didn't want to disturb existing graves, or thin soil over rock which prevented deep holes being dug, or even just personal preference.

Why don't the crosses still stand in the landscape?

Originally the crosses were scattered about the island. Even those used as grave markers wouldn't necessarily have been in a churchyard. Today we tend to think that all burials are the responsibility of the church, or, more recently, the state. However, before the ninth century, people expected to buried near their home not near their place of worship and so graves could be found all over the place. Burying Granny in the back garden would have kept the family together, so to speak. This is possibly why so many crosses were reused as steps, door

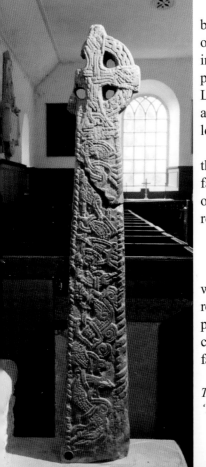

Thorlief's cross, Braddan old church. The runes on the right edge mean 'Thorleif Hnakki erected this cross to the memory of Fiac his son, brother's son to Hafr'

9

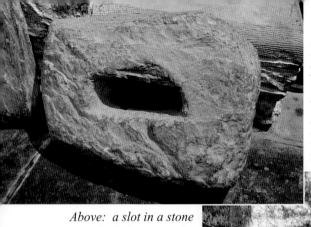

lintels, gate posts or other building materials: they were the grave markers of previous owners or tenants of that particular farm.

That the crosses have been rescued and preserved is largely down to the son of William Kermode, chaplain of St Paul's Ramsey, later Vicar of Maughold and Rector of Ballaugh. His son, Philip Moore Callow Kermode, better known as P.M.C. Kermode, followed his clerical father's interest in Manx antiquities, although he himself worked in the legal profession. He was the first director of the Manx Museum, when it was established in 1922, but is best known for his lifelong efforts to identify and preserve the Manx crosses.

Above: a slot in a stone into which the tine at the base of a cross was inserted to stand it up. Now in Braddan old church
Right: the base of the wheel cross at Lonan old church (see page 18) showing the tine-and-hole arrangement
Below: cross house built by P.M.C Kermode, St Maughold's church, Maughold

Kermode argued that 'these monuments, so few in number, are of priceless value, that their beauty and their interest consists in the intricate details of their sculpturings, and that every year's exposure to the weather alone, apart from the risk of accidental or wanton injury, is depriving future generations…'

Kermode began gathering the crosses together, either inside churches, such as at Kirk Michael, Andreas, Onchan and Bride, or inside specially built 'cross houses' such as the ones at Maughold and Lonan old church, or, once it was founded, in the Manx Museum. He also influenced others to take similar steps, so that almost all of the crosses and cross fragments are now protected from the weather. While today we would probably leave them *in situ*, where they were deemed to be in their original setting, moving

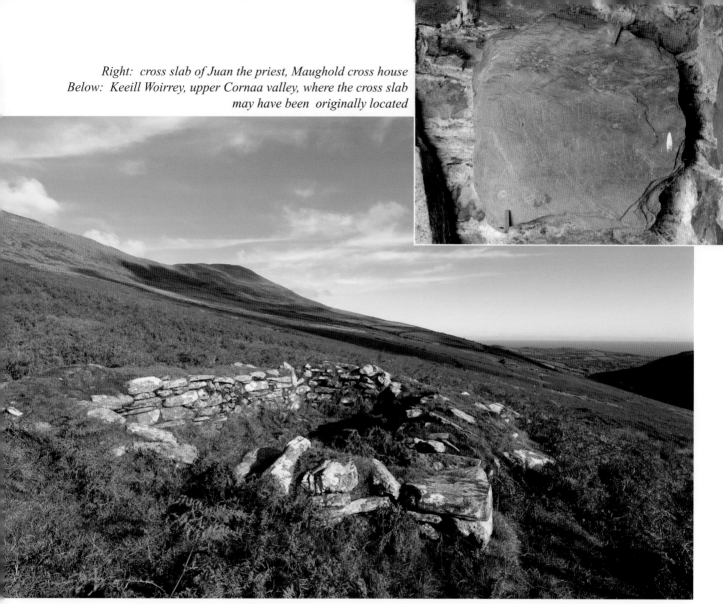

these elderly crosses into sheltered accommodation has undoubtedly slowed down further aging. The original sites of almost all the crosses on the island are therefore now only known from records of varying accuracy, many of which are unclear about the original position of the stone. To give just one example.

In 1889, the cross slab of Juan the Priest was found lying by the stream at the upper end of Cornaa valley by Rev Harrison. He was chaplain at Christ Church, Dhoon, the church at the bottom of the valley. The cross was thought to have come from Keeill Woirrey, or Mary's keeill, a chapel dedicated to the Virgin Mary, which lies just above where the cross was found. The inscription is in runes and Ogham, and of a very late date. It reads *Krisp Malaki Okbaþrik Aþamnan iinal sauþar Iuan brist Ikurnaþal* ('Christ, Malachi, Patrick and Adamnan! But of all the sheep is Juan priest

11

in Cornadale'). The stone might call on Christ and three Irish saints but Juan was stated as being the church's representative in Cornaa at the time. He was also something of a carver too, as another cross stone says: *Iuan brist raisti þisir runur* ('Juan the Priest cut these runes'). Having said all this, we only have proximity, conjecture and likelihood to show that these crosses came from Keeill Woirrey at all.

Only one or two crosses are thought still to remain where they were originally erected, and doubts have even been raised about those. The most famous of the crosses thought likely to be still *in situ* is the wheel cross next to Lonan old church (see page 18), but the simple arrangement of crosses now called St Patrick's Chair (see below), and said to be where he preached, may also still stand on their original site, as might the damaged cross in Keeill Kickle on private land near Jurby Church (see left).

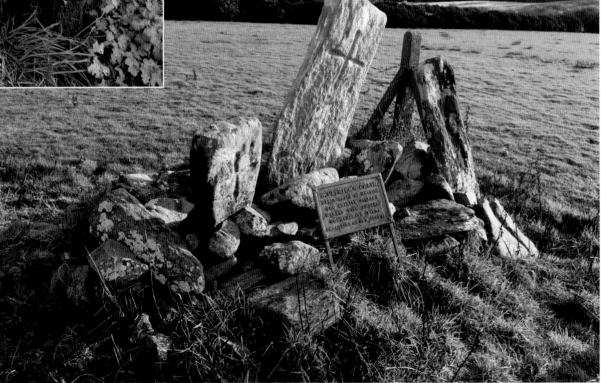

Think about massive blocks of shaped stone and the tendency is to assume that they date from the Stone Age. This is not the case for the Manx crosses: they are mediaeval. They started to appear around the fifth century AD, but became much more common from the middle of the seventh century, while the latest crosses date from around the eleventh century. To put that into context, the Manx crosses were first created around the time of St Patrick and Attila the Hun, became common in the era which saw the birth of Islam and the Sutton Hoo ship burial, and ceased being produced in any numbers roughly when building started on the Tower of London. The length of time the Manx crosses were being produced is approximately equivalent to the years between the life of Shakespeare and the first moon landing. 600 years is a lot of time for fashions to change.

Roman influence

Let's be clear about something. The Romans did not invade the Isle of Man, and did not settle here. Having said that, the Romans were perfectly aware of the island's existence – Julius Caesar wrote about it – and, given Rome's presence across the water, almost certainly had some contact with the Manx and possibly traded with them. 'Fair trade' shops today sell popular ethnic items from remote places; entrepreneurial Roman merchants could have offered similarly exotic Manx items to their rich customers during the first centuries AD.

Not only might the Romans have had direct contact with the Isle of Man, they could have had indirect influence on it too. The Manx are Celts, and at least three of the other five Celtic nations – Wales, Cornwall and, particularly, Brittany, known to the Romans as Gaul – were under Roman rule. Ireland and Scotland, of course, were never conquered by Rome, and the Isle of Man has most in common with its northern and western neighbours, but for a seafaring people to have had no contact at all with the people who live on a land visible from their home is surely doubtful.

Christianity had become the official religion of ancient Rome in 380, but it had little time to affect Britain as the Romans abandoned their north-west province around 400, and much of England reverted to paganism. Ireland, which became Christian about the time the Romans left Britain, took no notice of its neighbours' backslidings, however, and even preserved Latin, the language of Rome, for use in church. During the sixth and seventh centuries the Irish sent missionaries to England, Scotland, Gaul and Germany. Almost certainly the Irish did not ignore their closest neighbour, the Isle of Man.

Several Manx crosses carry Latin inscriptions. Avitus's stone (Santon 29, see right) says simply: *avit- mono ment-* (Avitus monument or tomb). The stone dates from the sixth century and might even indicate that Roman merchants continued to trade with the island. The name was a common one in Rome, and the style of the monument is similar to Christian stones found in Wales, Scotland, Cornwall and Ireland – the other British Celtic countries.

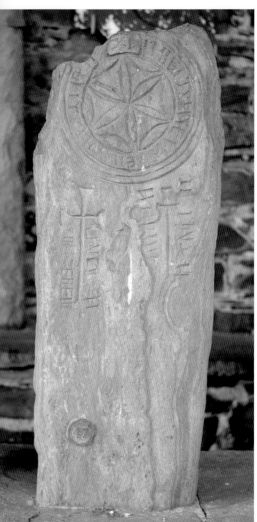

Maughold was the site of a large monastery, so it's perhaps no surprise that other Manx crosses with Latin inscriptions were found and are housed there. Itspli's cross (sometimes called Irneit's cross, see left) has been dated to both the seventh and ninth centuries, but its age is not what makes it interesting. Within the borders of the circle at the top of the cross is a damaged and rudimentary Latin inscription which says: *XPI NO NE ITSPLI EPPS DE I* (*NN* possibly; note that *N* is carved as *H*) *SVLI*; the rest of the roundel inscription is not clear. The Latin inscription is thought to mean 'in the name of Christ, Itspli, bishop of this island'. The earliest known 'official' bishop of the Isle of Man is Roolwer, enthroned about the middle of the eleventh century. Itspli therefore predates him by at least two hundred years. However, the word 'bishop' originally meant 'overseer' or 'supervisor', so perhaps Itspli was a senior figure in the monastery and therefore also responsible for lay Christians.

One particularly interesting grave marker – it's a tall stone so can't really be called a cross – was found at Knock y Doonee, Andreas. Now in the Manx Museum it dates from the sixth century and carries dual language inscriptions in both Latin and Ogham (see below for more about Ogham) which mean largely the same thing. The Latin *ammecat filius rocat hie jacet* translates as 'Ambecatus son of Rocatus lies here'. The Ogham inscription is now incomplete but what exists can be read as *...b...catus maqi Rocatus* or 'Ambecatus son of Rocatus...' Does the use of both Latin and Ogham script indicate a separation of church and laity, show that there were two different communities with their own languages, or celebrate merging cultures?

The earliest crosses

The very early Manx crosses are also the simplest, often without noticeable decoration and, if they carry an inscription, it's usually in Ogham. Irish missionaries introduced Christianity into the Isle of Man in the fifth century, and Ogham was a system of writing widely used in Ireland at the time. The Ogham alphabet is based on a series of straight lines marked at right angles to or across a single unifying line or edge, such as the edge of a stone. Ogham is read as a tree grows, i.e. from bottom to top, although if carvers reach the top of a stone they will carry on down the other side. Ogham's simplicity and ease of carving makes it very useful for inscribing standing stones.

The Bivaidonas stone, found at Ballaqueeney, Rushen, now in the Manx museum. The Ogham says: Bivaidonas maqi mucoi Cunava(li) *which means, 'of Bivaidonas, son of the tribe Cunava(li)'*

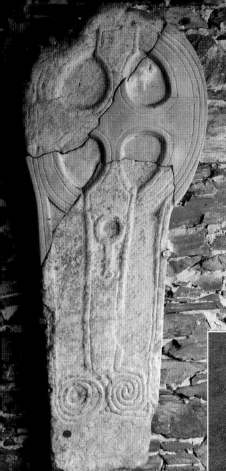

Decoration, if it existed at all on the early Manx crosses, usually consisted of swirling lines which flowed but did not overlap or interlace. The cross known as Lonan 71, now in Lonan cross house (see left) has a good example of early decoration at its base. Spirals are often associated with Celtic art, particularly in Ireland and Northern England, although they have existed as an art form for over 5,000 years. They are often reproduced in pairs or threes and are thought to be the origin of the three legs of Man.

The middle period

Manx crosses are probably most memorable for their magnificently intricate knotwork or interlacing, sometimes called icovellavna. Such designs were first used to illustrate religious texts such as the famous Book of Kells, and were introduced to the Isle of Man in the sixth century, almost certainly by Christian missionaries, and probably from Ireland. The new possibilities for overlapping and intertwining lines were incorporated into the older Celtic style of swirling patterns where the lines did not cross.

Charting out such complicated patterns is difficult. Today we would use a computer-aided design package or graph paper to draft out the pattern and make small adjustments to it. It is not impossible that carvers did something similar with parchment, but that was expensive, so it is more likely that they would have roughed out the design on a smoothed patch of earth or sand,

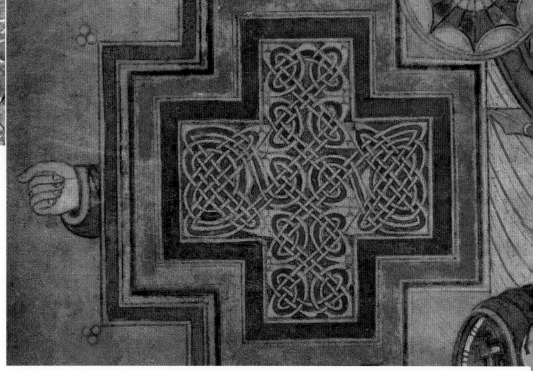

Part of the illustrated border from folio 291 of the Book of Kells
Photograph © The Board of Trinity College Dublin

possibly within a wooden framework to keep it from accidental erasures. The completed design would then be drawn out on the stone, probably in sections, using chalk, a mud paste or possibly a dye paint. There is some evidence that the intersections of the lacing, or the centres of circles were marked by drilling small holes to ensure that the carver maintained the correct line – Joalf's cross in Kirk Michael, for example, (see page 21) shows very small holes marking where the interlacing needed to turn at the bottom. There has even been some thought that the crosses were originally painted in bright colours, but so scarce are the traces that it's very difficult to determine whether the paint was applied when the cross was new, or added since, either deliberately or accidentally. And, due to lack of skill, lack of time, or some sort of oversight, carvers do occasionally appear to make mistakes. The lower half of the cross shaft of the dragon cross in Kirk Michael appears at the very least to show a radical change of mind by the designer (see left)

The later crosses

Vikings first raided the Isle of Man in 798 and settled here probably by the middle of the following century. The Norsemen revolutionised life on Mann of course, but also influenced the style of Manx crosses. The Vikings were pagan and many of the Scandinavian designs of the time were populated with stylised representations of mythical beasts which, of course, began to appear on the Manx crosses. In England the invading Saxons also brought with them Germanic designs for stylised animals, but Saxons across the sea would have less influence on the Manx carvers than Vikings on the doorstep.

And it wasn't only figures and animals that the Scandinavian designers shared with the Isle of Man. A particular motif known as the Borre (named after finds from the ship-burial at Borre, Vestfold, Norway) appears frequently on Manx crosses. Sometimes called a ring chain (*not* a borre-ring!), the design is unusual on the Isle of Man in that it usually appears upside down, or at least the opposite way up to the same design in Scotland and the north of England. This begs the question as to why. It's possible that the carver just preferred the design like that, but, setting personal preference aside, the likeliest answer seems to be that the carver(s) who copied the design saw it while it was being carved, i.e. flat, without knowing which way up the monument would eventually stand. Alternatively carvers saw or traded for mediaeval pattern books in which they found the design.

Such books did exist and carvers were also known to keep small pieces of stone carrying carved motifs as *aides memoires* to various designs. If carvers did communicate designs in this way, then it suggests a high degree of co-operation, or at least cross fertilisation of ideas between the Isle of Man and its nearest neighbours (see chapter 4).

The Borre appears on Gautr's cross (see page 4), and seems to be a favourite design on the Isle of Man, as other crosses on the island such as Sandalf's's Cross (see page 20) and Thorstein's Cross, in Braddan old church also display the ring chain. It is even possible, if a little unlikely, that, instead of Norse visitors bringing the design to the island, they copied Gautr's design and exported it.

Celtic designers, like all good artists, adopted new ideas without necessarily relinquishing their old templates. Consequently any design which incorporates interlacing spirals plus animal shapes shows the influence of three different traditions; Celtic in the swirling patterns, Christian in the knotwork and Norse in the animals.

Changing shape

Not only the style of carving changed over the years, but the crosses themselves also changed. The early ones were cut or incised into a roughly rectangular slab. Several of the crosses illustrated in this book are like this. Later crosses show that carvers began to remove more of the stone's surface, leaving the cross shape and its designs in low relief.

Later still the carver pierced the stone to give emphasis to the design, usually removing the inner part of the ring around the cross head; by this time carvers had presumably learned how to guard against the slate accidentally splitting. Thor's cross at Bride (see overleaf) is a good example.

From here it was only a small step to the cross 'escaping' from the slab, as carvers removed everything which wasn't a free standing cross shape, creating something which was much more like what we would now recognise as a standing cross.

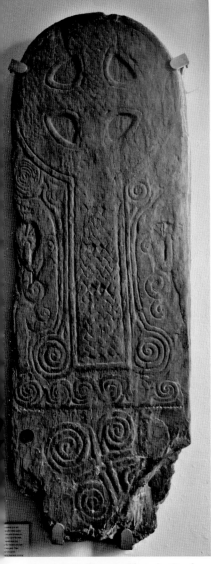

Cross in St Peter's Church, Onchan showing three different design traditions, Celtic, Christian and Norse

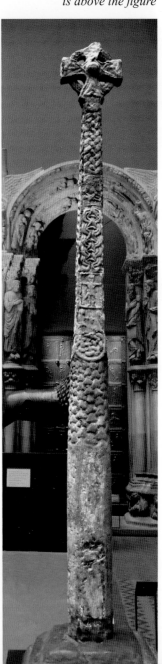

Plaster cast in the Victoria & Albert Museum, London, of the cross standing in St Mary's churchyard, Gosforth, Cumbria. The Borre design is above the figure

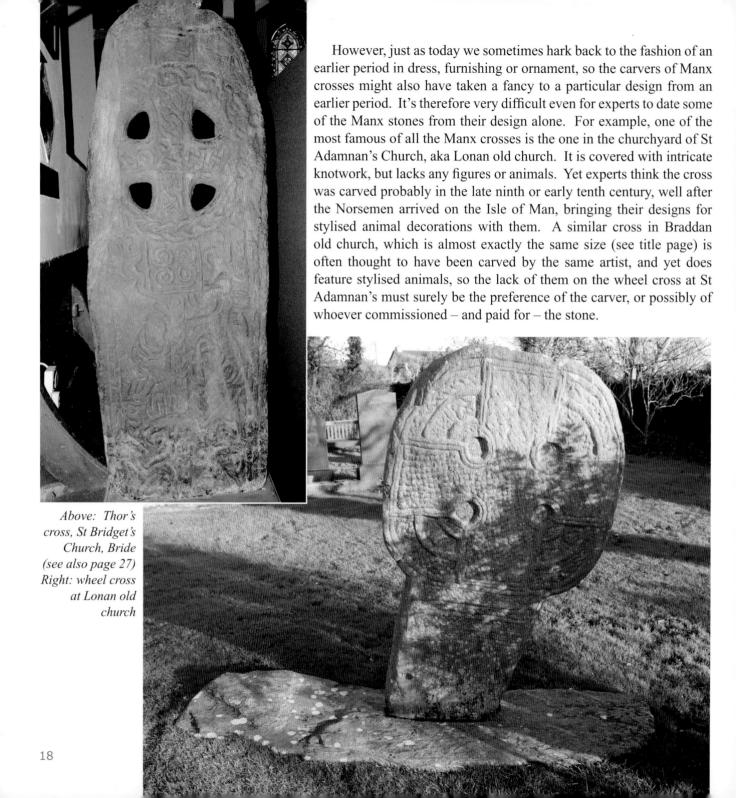

However, just as today we sometimes hark back to the fashion of an earlier period in dress, furnishing or ornament, so the carvers of Manx crosses might also have taken a fancy to a particular design from an earlier period. It's therefore very difficult even for experts to date some of the Manx stones from their design alone. For example, one of the most famous of all the Manx crosses is the one in the churchyard of St Adamnan's Church, aka Lonan old church. It is covered with intricate knotwork, but lacks any figures or animals. Yet experts think the cross was carved probably in the late ninth or early tenth century, well after the Norsemen arrived on the Isle of Man, bringing their designs for stylised animal decorations with them. A similar cross in Braddan old church, which is almost exactly the same size (see title page) is often thought to have been carved by the same artist, and yet does feature stylised animals, so the lack of them on the wheel cross at St Adamnan's must surely be the preference of the carver, or possibly of whoever commissioned – and paid for – the stone.

Above: Thor's cross, St Bridget's Church, Bride (see also page 27) Right: wheel cross at Lonan old church

FANTASTIC BEASTS AND WHERE TO FIND THEM...

One of the most striking elements of the Manx crosses, at least to modern eyes, is how they incorporate non-Christian elements within an obviously Christian symbol. Vikings invaded the Isle of Man from 798 and had settled here by about half way through the ninth century. The island was Christian, but the new rulers were pagan. However the Viking invaders were pragmatists and often married Celtic women, daughters of the leading families, to consolidate their land holdings. The two cultures therefore began to merge.

It's difficult to be sure exactly how many gods the Vikings recognised as several had more than one name, but probably nearly 200. Having so many gods made it easy for the Vikings to accept their new country's faith; the Christian God merely made one more in their pantheon. Tales of the Norse gods were mingled with Scandinavian history and legend, and were composed into long story poems or sagas. As these were the Vikings' way of remembering their past it's hardly surprising that figures from the sagas began to be appear on Manx crosses, often next to obviously Christian symbols.

Thorwald's cross in Kirk Andreas is a good example. Although only a fragment of it survives, one side (see below left) illustrates part of the story of Fenrir. A huge and very fierce wolf, Fenrir was shackled to a rock by the Norse gods until Ragnarök or the end of the world. Freed by the destruction of the world, Fenrir revenged himself by devouring *Óðin* or Odin, the senior god. The Thorwald cross shows Odin, holding his spear Gungnir, and with one foot in Fenrir's mouth. The bird on Odin's shoulder is one of his two ravens Huginn, representing thought, or Muginn, representing memory.

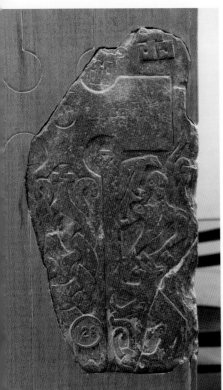

On the other side of Thorwald's cross (see right) is a Christian figure, holding a cross and a book and standing next to a fish, which are all Christian symbols. Interestingly there are two knotted serpents above and below the figure. They could refer to Genesis 3:15: 'I will put enmity between you [the serpent] and the woman, and between your offspring and hers; he shall bruise your head and you shall bruise his heel'. Or it could refer to Psalm 91:13: 'The serpent you will trample underfoot...' They could be mere decoration or could even be a sly reference to the Norse *Niðhöggr* or Nidhogg, a serpent who represented evil (see page 23).

Thorwald's cross, St Andrew's Church, Andreas. Runes on the edge should be read from top to bottom, not, as is usual, from bottom to top. They say: 'Thorwald erected this cross, then there shall come one mightier, though him I dare not name'.
Thorwald evolved into the name Walter.
Note: the cross is now displayed without its wooden support

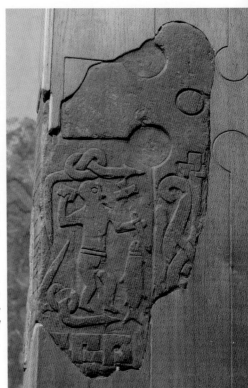

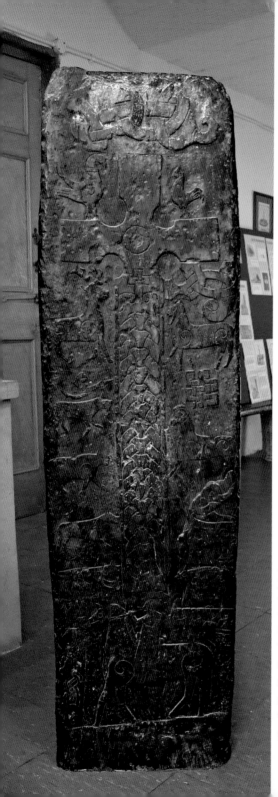

Sandulf's cross (left and right), also in Kirk Andreas, is a another example of a mixture of pagan and Christian imagery. Runic inscription along the edge says: 'Sandulf the Black erected this cross to the memory of Arinbjörg his wife.' The name Arinbjörg is unusual and comes from 'arn' meaning an eagle and 'björg' a hat or helmet. Together the name means 'protection of the powerful eagle'. Both sides of the cross slab have a Celtic cross with a long shaft, topped with Celtic knotwork which might be intended to represent the crown of thorns. More striking, however, is the array of animals which flank the cross on one side and climb it on the other. They appear to be hunting scenes. On the side where the figure on horseback sits (see left), the right-hand bird perched on the arm of the cross is usually taken to be a cockerel: could the larger bird facing it and wearing a collar, be an eagle and therefore a rebus on Arinbjörg's name? Could it even indicate falconry in the hunt?

Known animals... or maybe not?

On one side of Sandulf's cross a hound brings down a deer, with another hound circling a varied herd of animals, all of whom are walking up the cross shaft (see right). On the other side the animals are facing the cross with a horseman or possible horsewoman at the bottom. Odin was not only the senior god but also god of the dead. He was often associated with a wild hunt across the sky accompanied by packs of

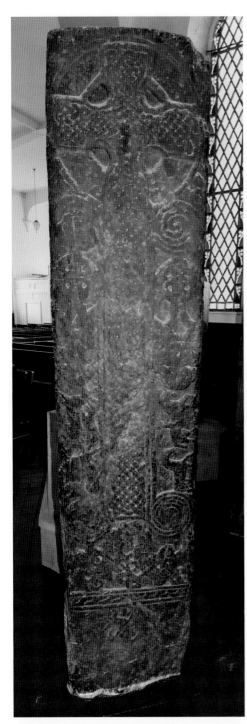

wolves and ravens. The two birds perched on the cross arms might even be Huginn and Muginn, respectively representing thought and memory.

The wild hunt appears in various guises and in various countries but always seems to be associated with tragedy and death. Christian symbolism doesn't really cover hunting, but Norse symbolism does. One Scandinavian legend even talks of the hunt collecting the souls of the dead. In the Isle of Man, where the new paganism of the Vikings was being merged with the existing Christianity, it's perhaps not surprising that both traditions contribute their symbols to Arinbjörg's memorial.

Sandulf's cross is not the only Manx cross to display hunting scenes; there are several others. Half of a smallish cross survives in Maughold (see right) which clearly shows another hunting scene with animals walking up the cross shaft. And the hunting scenes on Joalf's cross in Kirk Michael – one of the largest of the Manx crosses (see left) – are complete with horses and at least one rider, as well as animals, Again the animals walk up and down the cross shaft, at least on one side. On the other, the side shown, they still walk up and down but this time with their backs to the shaft. We can only guess why.

It's also interesting that the crosses frequently depict deer, which do not exist on the Isle of Man. The famed Irish Elk (neither Irish nor an elk, but a giant relative of the fallow deer) whose fossilised skeleton can be seen in the Manx museum, died out on Mann around 7,000 BC – too early for the Manx cross carvers. The Earl of Derby introduced deer to the Calf of Man in the eighteenth century (although the deer later died out, possibly because venison made a tasty and substantial meal for local subsistence farmers) – too late for the Manx cross carvers. Had the carvers of the Manx crosses actually seen deer, either on the island or elsewhere? Or were they merely following tradition, descriptions or a pattern book?

Joalf's cross, St Michael and All Angels church, Kirk Michael. The runes say: 'Joalf, son of Thorolf the Red erected this cross to the memory of Fritha his Mother'. Note the two small crosses on either side of the large central one, about a third of the way down the stone. It has been suggested that the three together represent the three crosses of Calvary

Hunting scenes occur even on crosses with a more rigorously Christian theme. A large plain cross in Maughold cross house has two seated figures, dressed like monks on either side of a plain cross shaft (see picture on page 29). Below them are figures of huntsmen and an animal generally taken to be a boar. From comparisons elsewhere experts have suggested that the two seated figures represent the fourth century saints Paul of Thebes and Anthony the Great. Anthony had given everything he had to the poor and was living alone in the desert. In a dream he was told of Paul, who had been living as a desert anchorite for ninety-seven years. Anthony found him and they talked for a night and a day, after which Paul died at the age of 113. Anthony is generally known as the father of all the monks, and Paul as the first hermit.

Although obscure today, the story was very popular around the time the crosses were carved. It's entirely possible that a mediaeval carver incorporated the two saints into his design. However it's equally possible that he merely thought it a good idea to incorporate a couple of monks from the local monastery which was situated in Maughold at the time. They might have been paying for his work!

Fantastic beasts...

Hunting scenes contained animals recognisably of this realm, but many of the crosses carry images of fantastic and fabulous animals. Only the base survives of Odd's cross at Braddan old church, for example, but one face of it is carved with crocodile-like serpents, ending with a spiral for a tail (see left). Like deer, the Isle of Man has no serpents or snakes, so again the carver was illustrating something he may never have seen.

The stone is called Odd's cross because the runic inscription reads 'Odd raised this cross to the memory of his father Frakki, but Thor…'. The cross breaks off at this point and, as runes are read as the tree grows, i.e. from the bottom upwards, the rest of the inscription is lost. The depiction of serpents could be alluding to Jömungandr which, in Norse mythology, is a huge sea serpent and the brother of the wolf Fenrir (see page 19). Interestingly Jömungandr's main enemy is Thor, who is also mentioned on the cross. Jömungandr grew so large that it circled the whole world and could grasp its own tail in its mouth, so was sometimes also called the Midgard or World Serpent. Could the spirals of the carving be indicating the world? According to legend, when Jömungandr lets go of its tail, Ragnarök, which is the end of the world, begins. The disadvantage of thinking that the carvings represent Jömungandr is that there are two serpents and Jömungandr is unique.

Not that Norse carvers restrict themselves to only one iteration of mythical beings on their crosses. Although very much worn (and therefore not pictured here), experts agree that one of the crosses at Jurby depicts, below the cross arm, the legend of Sigurd and Fafnir. Fafnir began life as a dwarf, but killed his father Hreithmar for his huge mound of gold. Fafnir then changed into a dragon in order to guard it; J.R.R. Tolkein based the dragon Smaug in his book *The Hobbit* on Fafnir. Advised by Odin, Sigurd kills Fafnir for his gold and then cooks his heart, as whoever eats the heart of a dragon is given knowledge of how to talk to and understand birds. The Jurby cross shows Sigurd stabbing the dragon Fafnir and then shows Sigurd again further down, roasting the dragon's heart.

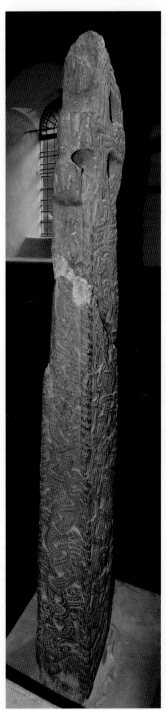

Thorlief's cross (see left), also at Kirk Braddan, is probably around the height that Odd's cross (see opposite) would have been had it been complete. Like Odd's cross it is a riot of intertwined serpents, which look very like the Odd ones(!). Unusually, there is one very long serpent on one side of the cross, his head at the bottom. Again this could be a reference to Jömungandr, but, if the interlacing tendrils are stylised branches, could refer to the third famous serpent in Norse mythology, Niðhöggr. Niðhöggr is a serpent or dragon who gnaws at the roots of the Yggdrasil, the enormous ash tree which, according to Norse mythology, is at the centre of the world holding everything together with its roots and branches.

The crosses don't, however, only depict huge mythical creatures of earth-shattering importance. They also show quirky little animals which seem almost incidental to any larger design. Why the carvers scattered animals across their designs we'll never know for sure. Perhaps they are the equivalent of doodling in stone and the carvers just liked them.

Portraiture

The Norse influence didn't end with introducing animal carvings onto the Manx crosses, they also introduced figure carving. Again there is the mix of Christian and pagan. The fragment of a cross slab from Kirk Michael, for example, is usually interpreted as a Christ on the cross (see overleaf). To modern eyes, the figure with its longish skirts and circles indicating breasts, looks more like a woman than a man. However, there are examples among carved Pictish stones, of men depicted dressed very similarly (see page 30). The Kirk Michael cross fragment is generally referred to as Grim's cross, as it carries the end of an inscription which says '…of Grim the Black'. The figure may well be intended to be Christ, particularly as, above it to the right, is a winged angel or seraph which often accompanies carvings of Christ.

Figures are more often depicted from the side, so one being carved full face indicates that the figure is particularly important. Unlike animals, most figures are usually identifiable, either as Christian saints or heroes from Norse sagas. The Heimdall cross at Jurby is so called from the figure standing on one of the cross arms, appearing to blow a large horn. Heimdall was watchman for the Norse gods, guarding Bifrost the rainbow bridge

Above: wild boar in Maughold cross house
Below: fire-breathing dragon at Kirk Michael

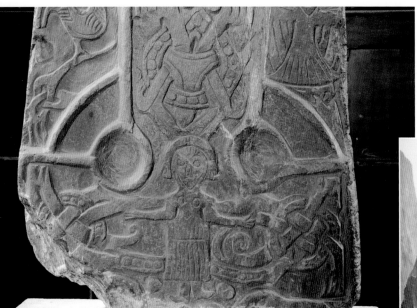

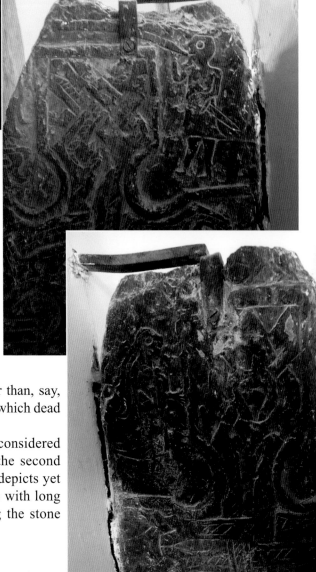

stretching between earth and heaven. His horn, Gjallarhorn could be heard throughout the cosmos and, when sounded, would bring the gods to the final battle at the end of the world. *Gjaller* in Old Norse means noisy or loud; we derive our word 'yell' from it.

On the other side or 'back' of the Heimdall cross a female figure with long hair is standing on the left hand cross arm. Were the cross undamaged, she would have been facing a second figure holding a staff standing on the right hand cross arm – the staff and hand grasping it still remains. Some experts have suggested that the figure is that of Hyndla, a goddess, giantess and seeress. Hyndla is an expert on genealogy and Heimdall was supposed to be descended from nine mothers, as well as being responsible for creating class distinctions on earth, so the connexion between the two figures might be understandable. It does seems something of a stretch however, to conclude that the figure is Hyndla rather than, say, Freya the goddess of love, war and death, or a Valkyrie who chose which dead warriors would dwell in Odin's hall.

Carved female figures are rarer than male, and only three are considered to exist on island crosses. Jurby has two of them, although the second figure isn't complete. The cross fragment numbered Jurby 125 depicts yet another hunting scene on one of its sides. At the top is a figure with long trailing hair, much of which is obscured by the clamp holding the stone

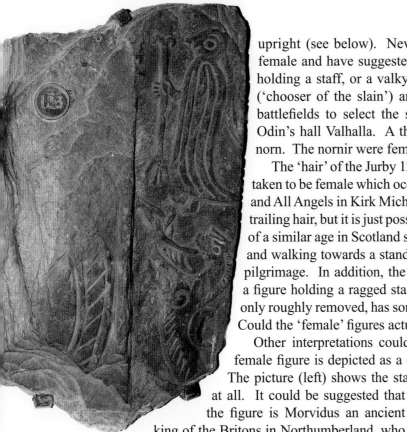

upright (see below). Nevertheless experts have assumed that the figure is female and have suggested either that she is a seer, who are often depicted holding a staff, or a valkyrie. Valkyrie comes from the old Norse *valkyrja* ('chooser of the slain') and were female servants of Odin who rode onto battlefields to select the souls of those fallen warriors worthy of sharing Odin's hall Valhalla. A third possibility is that the Jurby figure could be a norn. The nornir were female beings who ruled the destiny of gods and men.

The 'hair' of the Jurby 125 figure is very similar to the third figure generally taken to be female which occurs on a cross fragment in the church of St Michael and All Angels in Kirk Michael (see left). Again the figure appears to have long trailing hair, but it is just possible that the 'hair' is actually a cloak. Some crosses of a similar age in Scotland show a row of cloaked figures, each carrying a staff, and walking towards a standing cross. Such scenes have been interpreted as a pilgrimage. In addition, the general consensus among experts is that showing a figure holding a ragged staff, i.e. one used direct from the tree with branches only roughly removed, has some sort of religious significance not yet understood. Could the 'female' figures actually be cloaked pilgrims, therefore?

Other interpretations could also be suggested. In some cases the pilgrim/ female figure is depicted as a carrying a staff which looks like an uprooted tree. The picture (left) shows the staff as does the one opposite, the third (below) not at all. It could be suggested that the figure is Morvidus an ancient king of the Britons in Northumberland, who killed a giant using an uprooted tree stripped of branches and who was later killed by a water dragon emerging from the Irish Sea. Below the figure in the picture above is carved a dragon-like animal, which is possibly intended to be menacing Morvidus. In fairness, this explanation is highly unlikely as the legend of Morvidus was at its height in the fourth century, several hundred years before the Kirk Michael fragment was new. The Manx crosses also tend to figure Norse gods and heroes rather than British ones. However the idea does demonstrate that even experts can only express an opinion based on the knowledge of the time. Interpretations can be varied, arguable and very difficult to get right.

Jurby 125, St Patrick's church, Jurby. Partly obscured by the clamp is a female figure

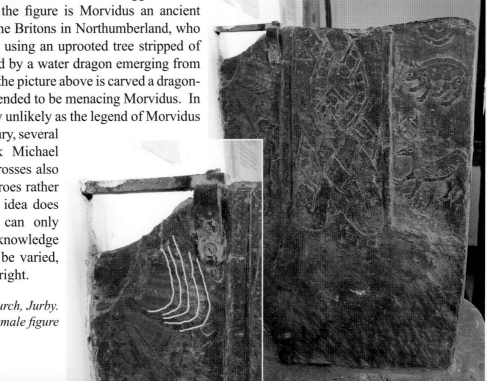

MANN IS NOT ALONE

The Isle of Man has a proud tradition of independence, but it doesn't exist in a vacuum, so it's hardly surprising that the Manx crosses share characteristics with inscribed stones in other countries, both Celtic and Scandinavian. The island's original Celtic culture was merged with that of Viking invaders, and the cross carvers themselves may have been taught by skilled craftsmen from different traditions.

From Iceland to Greece

The first to realise that the Manx crosses carry some of the earliest known illustrations of scenes from the Icelandic sagas was the Manx Museum's inaugural Director, Philip

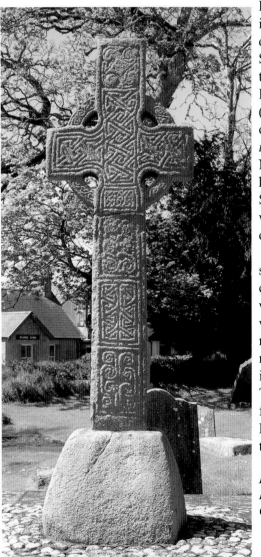

Kermode (see page 10), who was an internationally-recognised expert on Celtic and Viking antiquities. So important was his discovery that the Government of Iceland made him a Knight (*Riddari*) of the Order of the Falcon (*Hin íslenzka fálkaorða*). News of the high honour arrived on 5 September 1932. It was the day Kermode died.

One of the most striking of the Manx crosses is also one which demonstrates most clearly the Manx crosses' connexion with other traditions. The crucifixion scene found on the Calf of Man (see right above) is possibly the most famous Manx cross of all and differs radically in design from the other Manx crosses. It's Byzantine in style, i.e. similar to mediaeval artworks produced in the area around Greece. The cross was carved around 800 AD and almost certainly from slate found on the Calf. It shows the influence which the church in the eastern Mediterranean had on the Celtic church at the time: dignitaries from the two churches visited each other, and both claim a link with St Patrick.

Irish High Cross: the Castledermot south cross, Kildare, Ireland.
Photograph courtesy of Barney McLaughlin.
Compare the decoration with that on Thor's cross opposite

Looking West...

Ireland is the country probably most associated with St Patrick and the Isle of Man was officially ruled by the Irish until 800. Many of the motifs found on the Manx crosses therefore appear to have a lot in common with the Irish high crosses. Some of the interlacing 'filler' designs have definite similarities and it's interesting to note that the Irish crosses are much more common on the eastern side of Ireland, which is the side nearest to the Isle of Man. One notable difference between the two collections of Celtic crosses is that the Irish crosses carry a much higher proportion of Christian scenes.

The structure of the crosses of the two countries also differs radically. The design of the Manx crosses might be complex, but their construction is simple; much simpler than their Irish cousins. Manx crosses are most often carved onto slate slabs, while Irish high crosses are often made out of more than one block of stone carefully slotted together and designed to be viewed in the round.

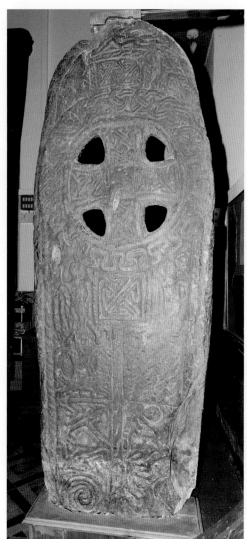

Thor's cross, St Bridget's Church, Bride (see also page 18). Although the style of the cross differs, the decoration is very similar to that on the Castledermot south cross opposite

... and North

Although the designs on Manx crosses are similar to designs on the Irish high crosses, some experts think that it is the shape of the cross, rather than its design, which makes the cross at Bride, and others like it, more like the Pictish crosses carved at the time. Picts lived in eastern and northern Scotland. The most noticeable difference between Irish crosses and Pictish crosses is in the wheel head. Crosses standing proud of the wheel such as Kirk Michael 117 (see page 16) tend to be in the Irish style, while crosses within the wheel, like that at Bride (see left), tend to be Pictish in style.

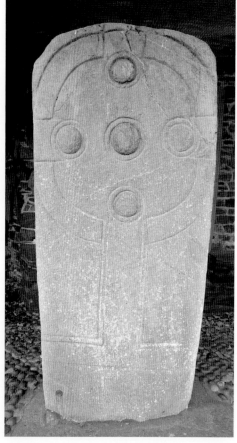

Pictish crosses are often adorned with stone bosses and an example of this sort of design also appears on some Manx crosses. The Guriat cross at Maughold (see right) while otherwise very plain, shows such bosses. Although looking like a simple design, producing such bosses is a skilful task as it requires the carver to remove much of the surface of the stone to allow

the bosses to stand proud. The other really interesting thing about the Guriat cross is that the cross shape hasn't actually been incised. Because of the placing of the bosses, the eye 'fills in' where the cross should be, but there is no sign that it was ever carved. Possibly because the type of stone used on Mann differs from that used in Scotland, the bosses on Pictish crosses tend to be both more numerous and more pronounced.

Another similarity between some Manx crosses and some Pictish ones occurs in the depiction of St Paul of Thebes and St Anthony the Great (see opposite and also page 21). The Manx version can be found in the Maughold cross house, while a Pictish version is housed in the church at Fowlis Wester, a small village in Perth and Kinross, Scotland. Another Perthshire cross slab, at Dunfallandy, which depicts similarly seated figures even has the same sort of chairs as can be seen in the Manx tableaux. Such similarities either indicate a remarkable coincidence or confirm some form of artistic sharing of ideas.

The similarities between Manx and Pictish crosses don't end there. The crucifixion stone, only a fragment of which remains at Kirk Michael (see picture at the top of page 24) bears a noticeable resemblance to a figure incorporated within another of the Pictish crosses (see page 30). Known as Meigle 2 the cross is very large – over 8 ft in height and about 3 ft wide. It is a Celtic cross, although an unusual one as experts think it was possibly copied from the design of a jewelled metal cross, rather than following the usual design of stone crosses of the time. In the centre of the back of the stone slab is a depiction of Daniel being eaten by lions. What is interesting from a Manx point of view is that the figure of Daniel is very similar to the figure of the crucified Christ on the Kirk Michael stone. In Christian terms Daniel is a herald or representative of Christ, so it would not be considered impious if the figures looked alike.

Most of the Pictish stones have been found on the east coast of Scotland which would seem to be a long way from the Isle of Man. Scotland's east coast, however, is on a direct sailing route from Scandinavia, and experts know that Norsemen often stopped there en route to and from the Isle of Man. It would not therefore be impossible for Norse carvers to have brought their designs to influence both the Picts and the Manx. Unproven, but an interesting idea.

England and Wales

Vikings from Norway first raided Lindisfarne on the north east coast of England in 793. By 850 they had settled the Western Isles of Scotland, the Isle of Man and eastern parts of Ireland around Dublin. They did

Dating from around 790-850 this cross, Aberlemno 3, can be found beside the road at Aberlemno, Angus, Scotland. On the back of the cross is an elaborate hunting scene. Many Pictish cross stones show a cross on the front and a hunting scene on the back, while the Manx style seems to be to incorporate the hunting scene around the cross (see pages 20-1)

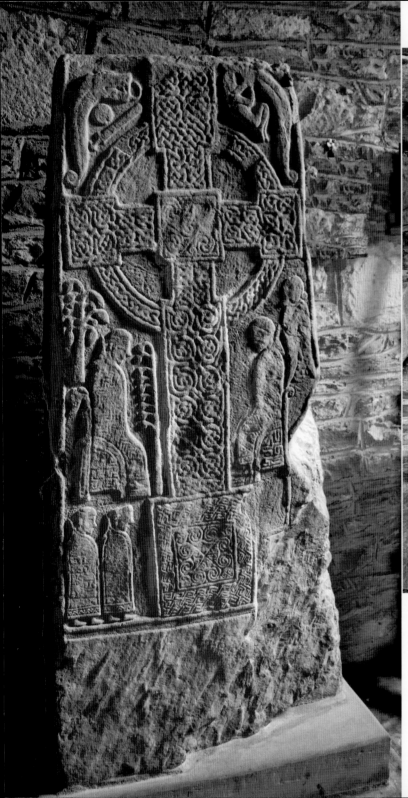
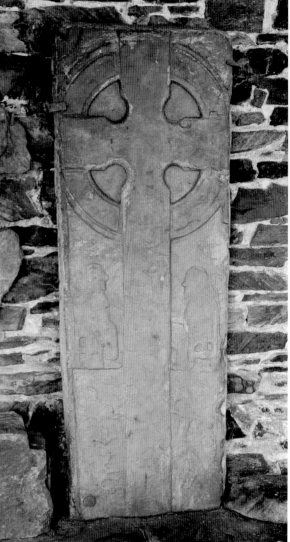

Above: Maughold 69, Maughold cross house, showing St Paul of Thebes and St Anthony the Great
Left: Fowlis Wester small cross, Perth and Kinross, Scotland, also showing St Paul of Thebes and St Anthony the Great. Photograph © Jo Woolf
The similarities are obvious

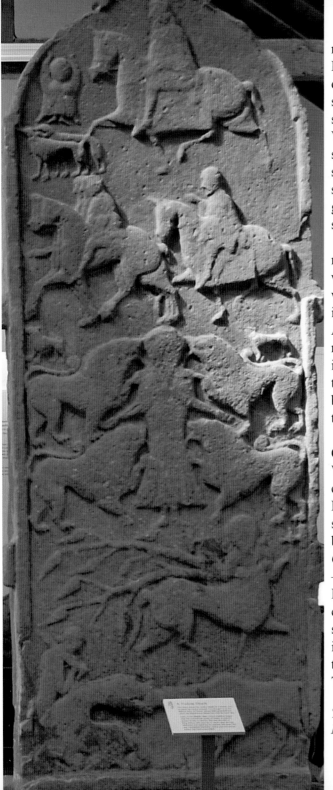

not however appear to settle in Cumbria, i.e. north west England. This was probably because the Danes had taken over the invasion of northern England and had themselves settled first the north west coast before moving slowly east and south. Cumbria was under the Danish Vikings; the Norwegian Vikings, out for plunder or easy territory, preferred attacking softer targets than their own fighting cousins. Consequently the stone crosses found in north west England, although showing some Scandinavian designs, were influenced by a different group of Vikings from those who helped shape the Manx stones and therefore show fewer of the same characteristics.

From the strategic point of view, the Isle of Man, in the middle of the Irish Sea, has always been a good base from which to dominate the shipping lanes. Consequently Vikings who settled here used Mann as a base from which to raid, invade or just visit and trade with the surrounding islands. Anglesey off north Wales was certainly subject to Viking raids and settlement and some of the Norse influence was incorporated into their stone crosses. The decoration on the two Penmon crosses in St Seiriol's Church – sadly we've not been able to obtain permission to reproduce a photograph of them – show similarities to some of the Manx crosses.

Reminiscent of the Manx wheel crosses is the Cross of Conbelin at Margam near Port Talbot in south east Wales. While obviously not the same as the wheel crosses at the old churches of Braddan (see title page), Lonan (see page 18) and Maughold (see opposite), their Welsh cousin shows definite similarities. The wheel of the Cross of Conbelin – so called because part of the lettering in the top left quadrant says *Conbelin posuit hanc crucem* (Conbelin erected this cross…) – is about the same diameter as the Manx pair at Braddan and Lonan, being 3 ft 5 inches in diameter; the Manx pair are a couple of inches smaller; the Maughold wheel cross smaller still. The heights are not wildly different either, although this is not such a good guide as only the Lonan cross is likely still to be in its original position and cross shafts are easily broken. The means of erecting the crosses are also the same, i.e.

The back of Meigle 2 showing Daniel in the lions' den, Meigle Museum, Perthshire, Scotland (see also page 28)

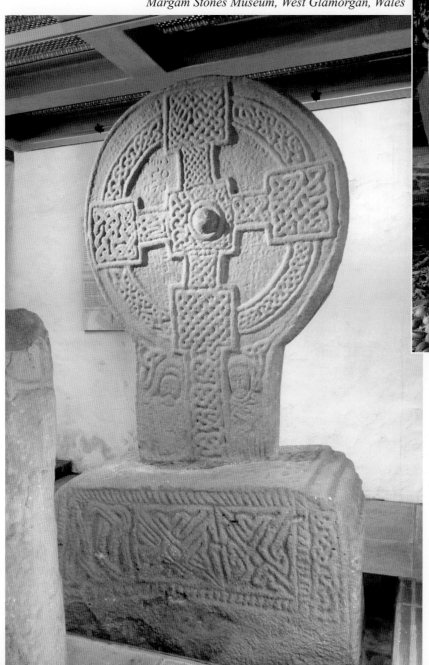

inserting a tine into a slot (see pages 9-10). Even the dates fit approximately. The Manx crosses are late ninth century and Conbelin's cross mid tenth century. Having said all that, the Welsh and Manx crosses look sufficiently different for there to be little doubt that they arise out of different cultures, but cultures which perhaps have a shared heritage and which influence each other.

Of the final two of the six main Celtic areas, Brittany's ancient stone crosses have little resemblance to those on the Isle of Man while Cornwall has a large number of old stone crosses most of which are unlike those on Mann. However there are a few Cornish

exceptions, in areas where Vikings were known to settle. In the early part of the ninth century, for example, there was a Cornish-Danish alliance against the Saxons of Wessex.

The Norwegian Borre motif (see page 16) appears on an ancient cross outside St Meubred's church at Cardinham, Cornwall (see right), although it's now very worn. A better example of Scandinavian-influenced design can be seen on Copplestone Cross in mid Devon – Vikings obviously didn't respect modern county boundaries – which is the remains of a wayside cross dating from the tenth century. Only a 10ft high shaft remains but it is covered with the sort of interlacing familiar on the Manx crosses. Such designs are rare in south-west England –

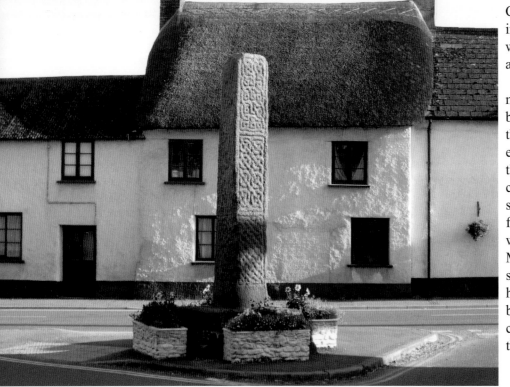

Copplestone's is said to be unique in Devon – but is, nevertheless, the work of a carver influenced by Celtic and Norse designs.

The Manx crosses are not only of major importance in their own right, but help complete the picture of how the various Celtic cultures influenced each other. Some academics even think that the prevalence of stone crosses in Rogaland and Sogn in south-west Norway, were due to the fact that pagan Vikings from that area were mainly responsible for invading Mann and Ireland. Even after they settled in their new homes they must have had connexions with family back in Norway. It seems that Norse carvers may have taken something of the Celtic style back home with them.

Copplestone cross, Copplestone, Devon, England. Photograph © Angela Lake